CLAY FUN

ACKNOWLEDGEMENT

The authors, Carolyn Davis and Charlene Brown, would like to thank all of the following for their patience and support: Sally Black, Sally Marshall Corngold, John Raley, Steve Crisafulli, Pat Brown and our friends at Marian Bergeson Elementary and of course, the wonderful staff at Walter Foster Publishing.

INTRODUCTION

Clay is a three-dimensional art form. You will use height, width and depth to create your clay objects. This helps develop your tactile and visual skills. If we really look at an object, we can picture the shapes necessary to re-create it with clay. In fact, using the methods in this book and your imagination, you should be able to create many wonderful, fun designs.

One of the most rewarding things about working with clay is that you can create objects that you can keep for a very long time. Perhaps you have a school project in mind, or you want to make a gift, or maybe you want to work with clay just for fun. Whatever the reason, you may find that three-dimensional art is the best art form for you.

You may also find that certain types of clay work best for you. To find out what kind of clay you like best, experiment with as many different types as you can. This is a great way to get started, because you can learn about the various qualities of each type of clay. For information on where to buy, make or work with clay, look on the materials page.

Whatever your intent in working with clay, remember to use the clay best suited for your project, plan out how you will create it, and use your imagination!

GLOSSARY

Bisque—Clay after it is dried, but before it is fired.

Cone—A standard of temperature measurement used in clay firing. When using a glaze on your pottery, you must make sure the cone number (firing temperature) is the same for both.

Dampen—To make moist by adding water.

Details—Any smaller parts of your whole object. Eyes, buttons, hats, etc. are all details that make a clay object more fun.

Fired, firing—Heating clay to a temperature that leaves the clay permanently hard.

Glaze—A coating or topping that goes over all or part of your clay object that seals the clay and leaves it with a smooth and/or shiny finish.

Kiln—A special furnace or oven for drying or baking clay.

Mold—Shaping clay with your hands.

Scoring—Roughing up clay to make it easier to stick together. Rough surfaces stay together better than smooth surfaces.

Slab—A broad, flat, usually thick piece of clay.

Slump—Allowing the clay to fall naturally, usually over another object.

Texture—The way something looks or feels. A clay object can be rough, bumpy, smooth, etc.

CONTENTS

1. FLAT CLAY SHAPES 9

2. THREE-DIMENSIONAL CLAY SHAPES 21

3. POTS AND VASES 33

4. PLACES AND FUN THINGS 45

5. PROJECTS 53

MATERIALS

TOOLS

You will need tools for cutting, rolling, piercing and shaping your clay. You can purchase special clay tools at a hobby store, or just use common household items like a pencil, fork, rolling pin, table knife, toothpicks, and popsicle sticks.

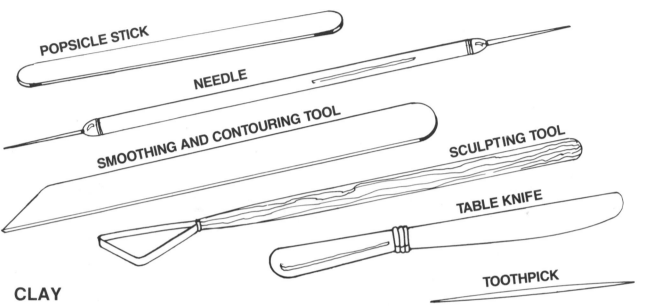

CLAY

There are several different types of clay available. Some are easier to work with than others and some are better for certain projects. You do not have to buy all the types listed here, but you should try two or three of them to see which ones you like best.

BAKER'S DOUGH CLAY —You can make this type of clay at home; it looks like cookie dough, but it is for modeling, NOT EATING!

Ingredients: Flour, Salt, Water

Directions: Mix one cup of flour with one cup of salt in a large mixing bowl. Add water, a little at a time, until it feels like clay. You can also add food coloring to the dough if you wish.

Once you have formed the clay into whatever shape you want, bake it in the oven at 200 degrees (be sure to ask an adult for help). Check the clay every five minutes until it is hard. The baking time needed depends on the amount of clay. When the clay cools you can paint it if you didn't color it first.

NON-TOXIC PLASTALINA CLAY — This clay is a non-hardening modeling clay that remains flexible so it can be used over and over again.

Plastalina comes in many bright, fun colors and can be purchased at art and craft stores, variety stores and toy stores.

MODELING COMPOUND CLAY— This clay comes in a variety of bright, bold colors and remains pliable until you bake it.

After molding the clay into the shape or object you want, bake it in your oven at 250 degrees for 15 to 30 minutes, depending on the size of the project. (For best results, cover the clay loosely with tin foil while baking.) Be sure to ask an adult for help baking!

After baking, this clay can be painted with acrylic paint if you wish. You can find Modeling Compound clay in art supply and craft stores.

MATERIALS

OVEN-HARDENING CLAY— This kind of clay is non-toxic, lab-tested, non-staining, and cleans up with water. It is ready to use when purchased.

Work with Oven-Hardening clay on wood, cardboard, or several layers of newspaper. It must be stored in a tightly sealed container so it won't dry out. An unfinished project should be covered with a moist rag or towel to keep it pliable.

Before you bake Oven-Hardening clay, it must be dried at room temperature, or in the oven at NO MORE THAN 150 degrees. Oven- Hardening clay that is still moist will crack when baked. Drying can take anywhere from a few hours to several days, depending on the size of the project.

When the project is completely dry (if the clay is cool to the touch it is still wet), you can either bake it in your oven or kiln-fire it at 2300 degrees (see baking instructions for Ceramic clay for information on kiln-firing). NOTE: If you bake oven- hardening clay in your oven instead of kiln-firing it, it cannot be used as a food or beverage container.

To bake Oven-Hardening clay, place it in a cool oven and bring the temperature up to 350 degrees. DO NOT open the oven until the temperature inside reaches 350 degrees. The average baking time is one hour. You will know it is done when dark brown specks appear on its surface. Then, turn the oven off and leave your project inside the oven until it is cool to the touch. NOTE: Always get an adult to help you bake the Oven-Hardening clay.

After baking or firing, this clay has a beautiful, speckled, red- brown stoneware color. The project is now ready for use or for painting. Painted Oven-Hardening clay will not peel. Acrylics, enamel, tempera, or watercolors may be used to paint it. It can also be stained or antiqued like wood. In fact, any paint, stain, or sealer recommended for wood can be used on Oven-Hardening clay. If you use this clay to make a planter or vase, it must be coated with a commercial sealant to make it waterproof.

Oven-Hardening clay can be purchased at hobby, craft, and art stores.

CERAMIC CLAY— Ceramic clay must be kneaded, just like bread dough, to remove the air bubbles, and can be worked with on wood, cardboard, or a smooth, clean cement surface. It should be stored in a plastic bag in a cool place, and must remain moist. If the clay becomes stiff, add a little bit of water and knead it into the clay. To keep an unfinished project moist for a period of time, place a damp rag or towel over it and cover it with plastic. Once your clay project dries, you cannot add more clay to it because the joint between the dry and moist pieces will crack while the new piece is drying.

Ceramic clay should be hollowed out whenever it is more than one inch thick. This is because the clay expands, like a cake, when it is baking, and it may crack if it is too thick. The clay will dry slowly and evenly if you place a piece of plastic loosely over it.

When your project is completely dry, it must be fired (baked) in a special oven called a "kiln" (pronounced "kill"). Before the clay is fired, but after it is dried, it is called "bisque." The first firing is called "bisque firing." The clay can be fired a second time to make it harder. A glaze which gives the clay a shiny, finished surface can be applied between the bisque firing and the second firing. Make sure the clay and the glaze have the same "cone number." This means that both are meant to be fired at the same temperature (see glossary).

It is best to buy ceramic clay and glaze with low cone numbers because most shops have the lower temperature kilns. Cone 06 (1873 degrees) to cone 04 (2008 degrees) is best. Always buy glaze that is marked "lead-free." Ceramic clay and glaze may be purchased at most art stores, some toy stores, and all ceramic supply stores. The clay can also be fired at most ceramic shops for a small fee.

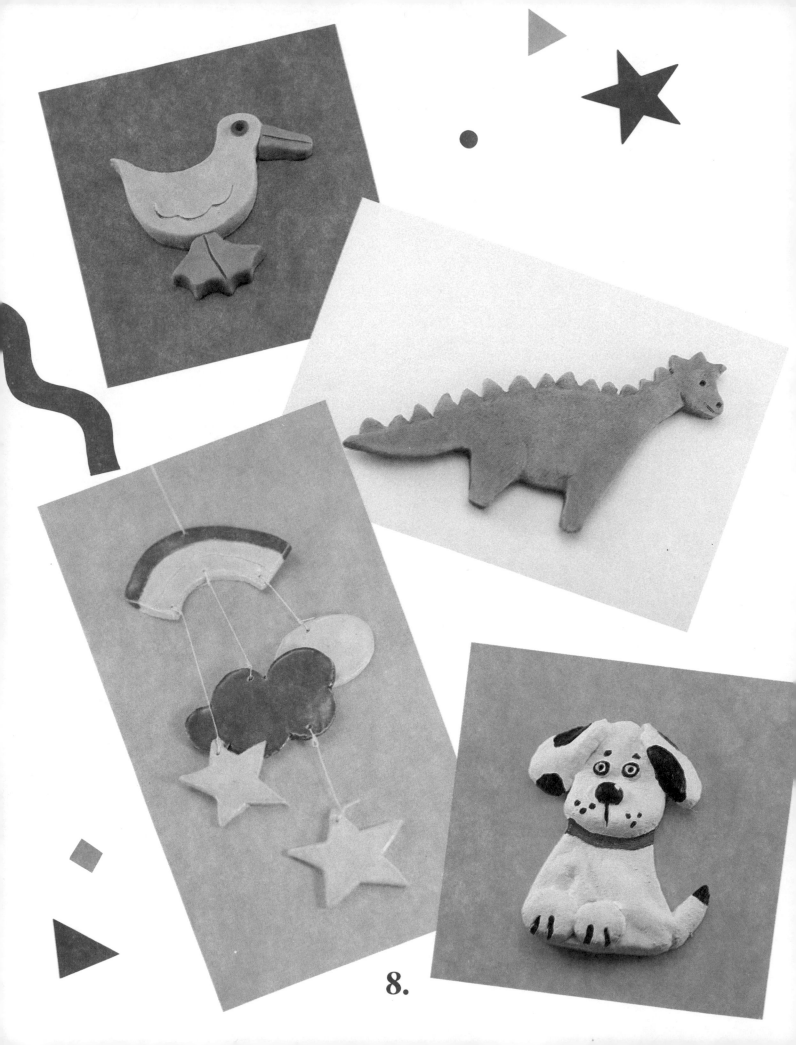

8.

1.

FLAT CLAY SHAPES

Making animals and other objects out of clay can be easy and lots of fun. It's amazing what shapes we can create using a rolling pin and a table knife (but be careful)!

We can add details such as the eyes, the nose, the eyebrows and the ears before the clay is dried. And, after most types of clay have hardened, we can paint our project with whatever colors we choose.

To find out what kind of clay you like best, experiment with different cutting tools and with as many different types of clay as you can. Learning about the various qualities of each type of clay is a great way to get started.

MAKE A DUCK

THIS PROJECT WAS MADE WITH NON-TOXIC PLASTALINA CLAY. IT CAN ALSO BE MADE WITH BAKER'S DOUGH, MODELING COMPOUND, OVEN-HARDENING OR CERAMIC CLAY. SEE MATERIALS PAGE FOR BUYING AND WORKING WITH THE TYPE OF CLAY YOU CHOOSE.

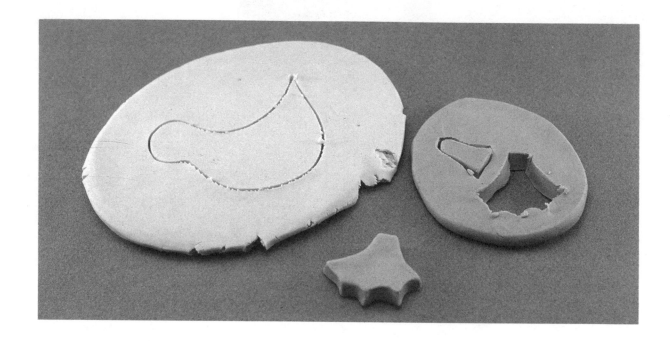

1. USING YOUR HANDS, ROLL CLAY INTO A BALL.

2. PLACE ON A FLAT, CLEAN, DRY SURFACE.

3. ROLL OUT FLAT WITH A ROLLING PIN.

4. CUT OUT EACH PART OF THE DUCK—THE BODY, THE FEET AND THE BILL—WITH A TABLE KNIFE (BE CAREFUL!).

5. SAVE EXTRA CLAY FOR ANOTHER PROJECT.

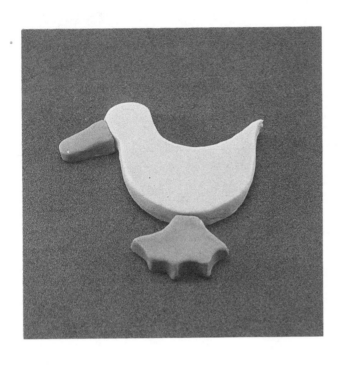

6. PUT THE PIECES OF THE DUCK TOGETHER, PUSH GENTLY TO MAKE THEM STAY.

7. ADD DETAILS SUCH AS THE EYES AND THE WINGS.

8. YOU CAN SAVE YOUR DUCK OR USE THE CLAY FOR ANOTHER PROJECT. REVIEW THE MATERIALS PAGE IF YOU USED A CLAY THAT NEEDS TO BE BAKED.

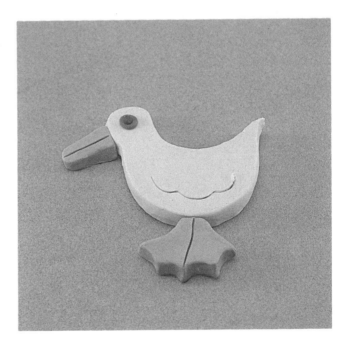

...OR A CAT

THIS PROJECT WAS MADE WITH MODELING COMPOUND CLAY. IT CAN ALSO BE MADE WITH BAKER'S DOUGH, NON-TOXIC PLASTALINA, OVEN-HARDENING OR CERAMIC CLAY. SEE MATERIALS PAGE FOR BUYING AND WORKING WITH THE TYPE OF CLAY YOU CHOOSE.

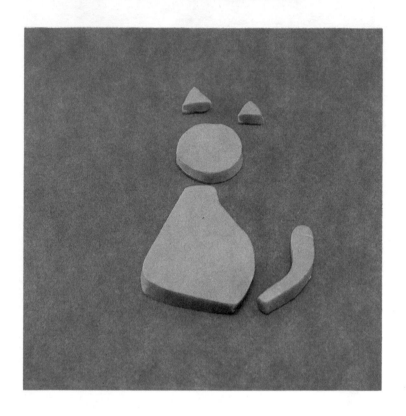

1. USING YOUR HANDS, ROLL CLAY INTO A BALL.

2. PLACE ON A FLAT, CLEAN, DRY SURFACE.

3. ROLL OUT FLAT WITH A ROLLING PIN.

4. CUT OUT EACH PART OF THE CAT—THE HEAD, THE BODY, THE TAIL AND THE EARS—WITH A TABLE KNIFE (BE CAREFUL).

12.

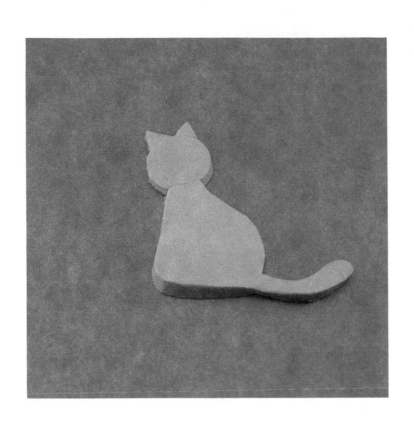

5. SAVE EXTRA CLAY FOR ANOTHER PROJECT.

6. PUT THE PIECES OF THE CAT TOGETHER, PUSH GENTLY TO MAKE THEM STAY.

7. ADD THE DETAILS SUCH AS THE EYES, THE MOUTH AND THE TOES.

8. IF YOU USED A CLAY THAT NEEDS TO BE BAKED, REVIEW THE MATERIALS PAGE FOR BAKING INFOR-MATION.

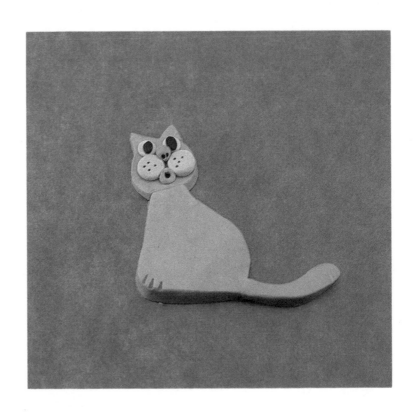

13.

MAKE A DINOSAUR

THIS PROJECT WAS MADE WITH OVEN-HARDENING CLAY. IT CAN ALSO BE MADE WITH BAKER'S DOUGH, NON-TOXIC PLASTALINA, MODELING COMPOUND OR CERAMIC CLAY. SEE MATERIALS PAGE FOR BUYING AND WORKING WITH THE TYPE OF CLAY YOU CHOOSE.

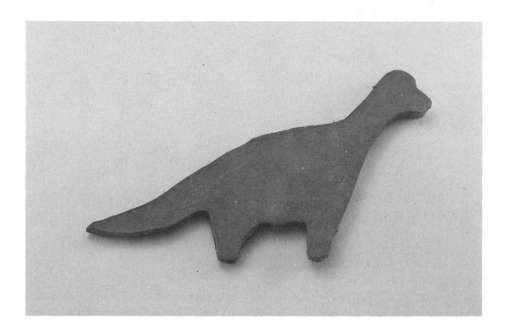

1. USING YOUR HANDS, ROLL CLAY INTO A BALL.

2. PLACE ON A FLAT, CLEAN, DRY SURFACE.

3. ROLL OUT FLAT WITH A ROLLING PIN.

4. CUT OUT EACH PART OF THE DINOSAUR WITH A TABLE KNIFE (BE CAREFUL).

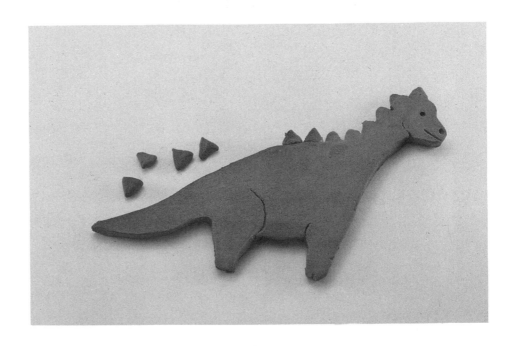

5. SAVE EXTRA CLAY FOR ANOTHER PROJECT.

6. ADD DETAILS SUCH AS THE EYES AND THE SCALES ON THE DINOSAUR'S BACK.

7. IF YOU USED A CLAY THAT NEEDS TO BE BAKED, REVIEW THE MATERIALS PAGE FOR BAKING INFORMATION.

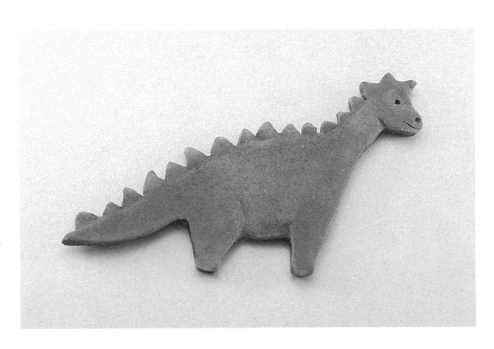

...AND A DOG

THIS PROJECT WAS MADE WITH BAKER'S DOUGH CLAY. IT CAN ALSO BE MADE WITH NON-TOXIC PLASTALINA, MODELING COMPOUND, OVEN-HARDENING OR CERAMIC CLAY. SEE MATERIALS PAGE FOR BUYING AND WORKING WITH THE TYPE OF CLAY YOU CHOOSE.

1. USING YOUR HANDS, ROLL CLAY INTO A BALL.

2. PLACE ON A FLAT, CLEAN, DRY SURFACE.

3. ROLL OUT FLAT WITH A ROLLING PIN.

4. CUT OUT EACH PART OF THE DOG—THE HEAD, THE EARS, THE BODY, THE FEET AND THE TAIL—WITH A TABLE KNIFE (BE CAREFUL!).

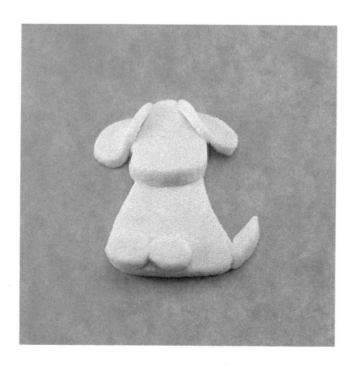

5. SAVE EXTRA CLAY FOR ANOTHER PROJECT.

6. PUT THE PIECES OF THE DOG TOGETHER, PUSH GENTLY TO MAKE THEM STAY.

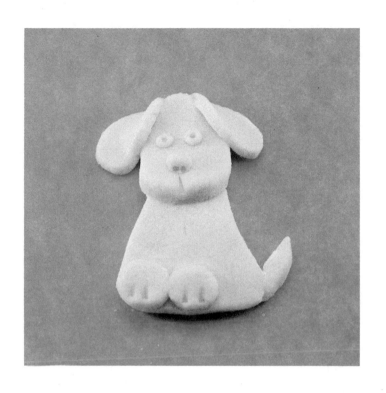

7. ADD DETAILS SUCH AS THE EYES, THE NOSE AND THE MOUTH.

8. IF YOU USED A CLAY THAT NEEDS TO BE BAKED, REVIEW THE MATERIALS PAGE FOR BAKING INFORMATION.

9. AFTER BAKING, YOU CAN PAINT YOUR CLAY IF NECESSARY.

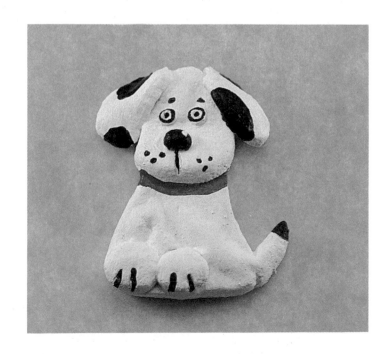

17.

MAKE A MOBILE

THIS PROJECT WAS MADE WITH CERAMIC CLAY. IT CAN ALSO BE MADE WITH OVEN-HARDENING CLAY. SEE MATERIALS PAGE FOR BUYING AND WORKING WITH THE TYPE OF CLAY YOU CHOOSE.

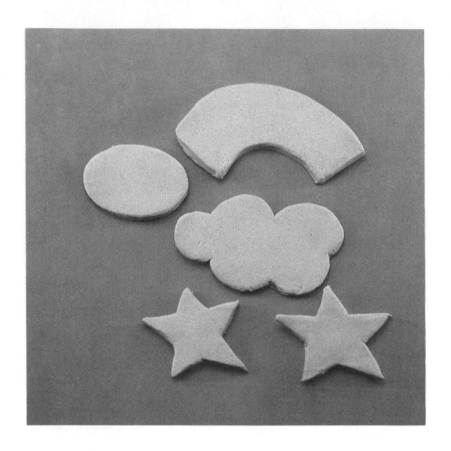

1. USING YOUR HANDS, ROLL CLAY INTO A BALL.

2. PLACE ON A FLAT, CLEAN, DRY SURFACE.

3. ROLL OUT FLAT WITH A ROLLING PIN.

4. CUT OUT EACH PART OF THE MOBILE— THE RAINBOW, THE CLOUD, THE SUN, AND THE STARS—WITH A TABLE KNIFE (BE CAREFUL).

18.

5. SAVE EXTRA CLAY FOR
ANOTHER PROJECT.

6. ADD DETAILS SUCH AS THE
LINES IN THE RAINBOW AND
THE HOLES TO HANG THE
PIECES.

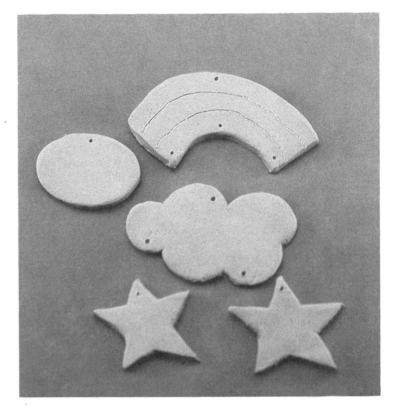

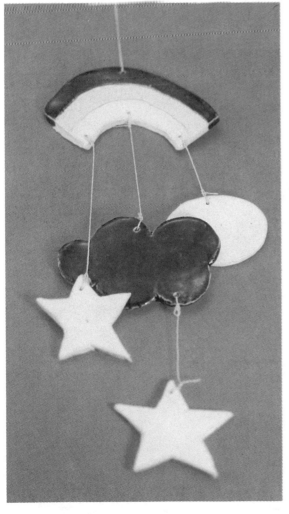

7. LET CLAY HARDEN AND DRY
BEFORE BAKING OR FIRING AND
GLAZING. REVIEW MATERIALS PAGE
FOR BAKING INFORMATION ON THE
TYPE OF CLAY YOU USED.

8. PAINT THE PIECES IF YOU WANT
TO, THEN STRING THE PIECES
TOGETHER FOR YOUR MOBILE.

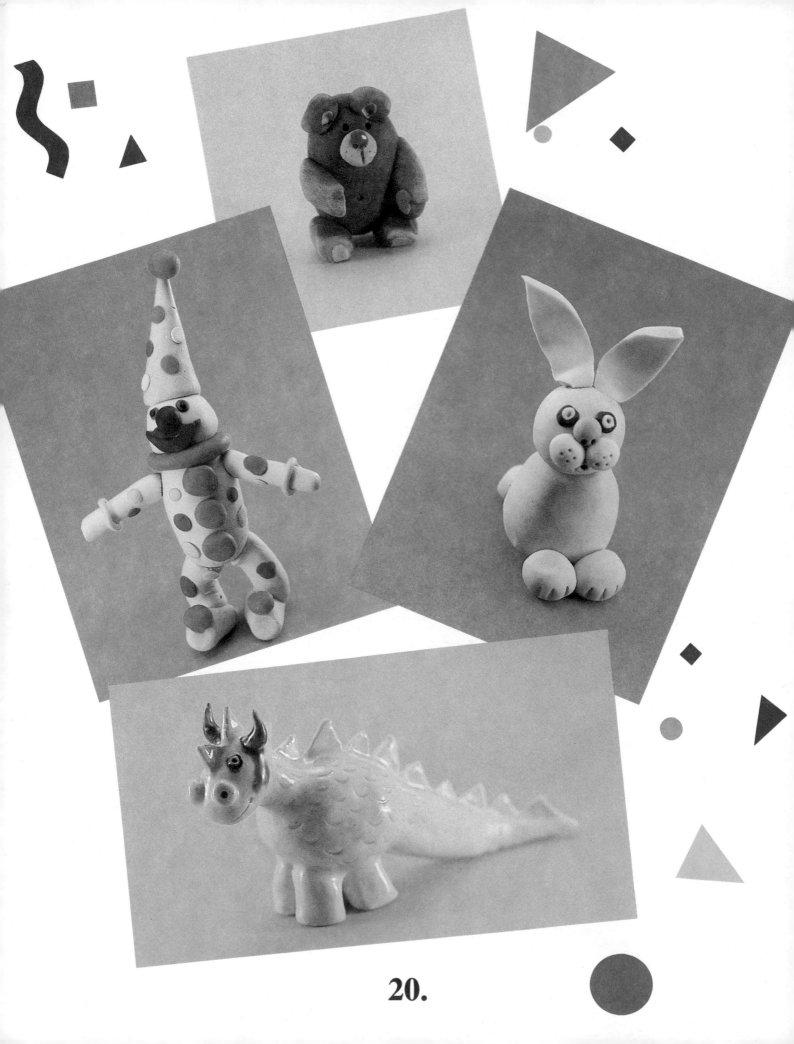

20.

2.

THREE-DIMENSIONAL CLAY SHAPES

Instead of using a rolling pin and a table knife to make flat shapes, now you're going to make three-dimensional shapes by rolling the clay with your hands; using the table knife only for details. Then, we can put these different shapes together to make anything you can think of. For instance, with two triangles, one big ball, four little round balls and one smaller round ball, you can make a pig.

Try all kinds of shapes, animals and other things with different kinds of clay. See how much fun it can be to create your own world of animal friends.

MAKE A BUNNY

THIS PROJECT WAS MADE WITH NON-TOXIC PLASTALINA CLAY. IT CAN ALSO BE MADE WITH BAKER'S DOUGH, MODELING COMPOUND, OVEN-HARDENING OR CERAMIC CLAY. SEE MATERIALS PAGE FOR BUYING AND WORKING WITH THE TYPE OF CLAY YOU CHOOSE.

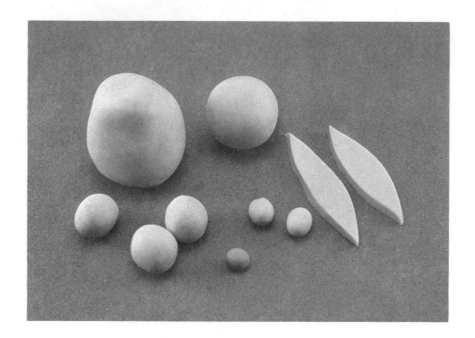

USING YOUR HANDS OR A SMOOTH, CLEAN SURFACE:

1. ROLL AN EGG-SHAPED BALL FOR THE BODY.
FLATTEN THE BOTTOM OF THE EGG.

2. ROLL A SMALLER BALL FOR THE HEAD.

3. ROLL THREE SMALLER BALLS FOR THE
FEET AND THE TAIL.

4. ROLL A VERY SMALL BALL FOR THE NOSE
AND TWO MORE LITTLE BALLS FOR THE CHEEKS.

5. FLATTEN A SMALL BIT OF CLAY AND CUT OUT TWO EARS.

6. PUT THE PIECES TOGETHER, PUSHING GENTLY TO MAKE THEM STAY. BLEND THE EDGES OF EACH PIECE ONTO THE MAIN BODY.

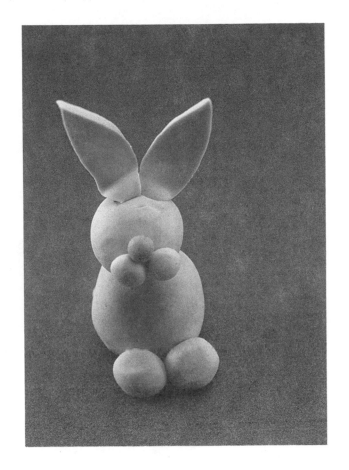

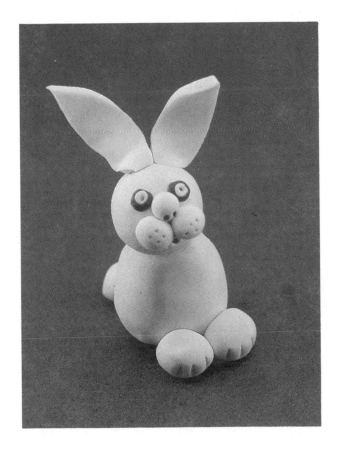

7. ADD DETAILS SUCH AS THE EYES, THE MOUTH AND THE TOES.

8. YOU CAN SAVE YOUR BUNNY OR USE THE CLAY FOR ANOTHER PROJECT. (IF YOU USED A CLAY THAT NEEDS TO BE BAKED, REVIEW THE MATERIALS PAGE FOR BAKING INFORMATION.)

COLORFUL CLOWN

THIS PROJECT WAS MADE WITH MODELING COMPOUND CLAY. IT CAN ALSO BE MADE WITH OVEN-HARDENING OR CERAMIC CLAY. SEE MATERIALS PAGE FOR BUYING AND WORKING WITH THE TYPE OF CLAY YOU CHOOSE.

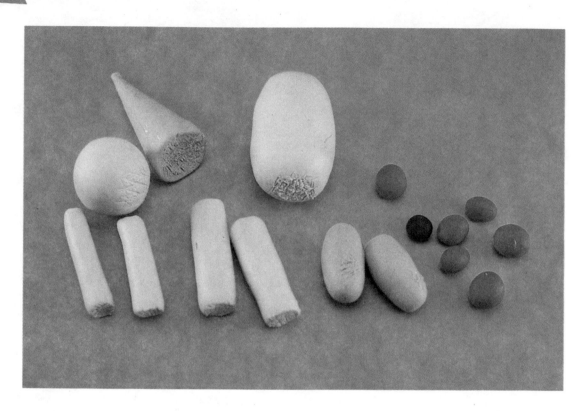

USING YOUR HANDS OR A SMOOTH, CLEAN SURFACE:

1. ROLL AN OVAL SHAPE FOR THE BODY.

2. ROLL A ROUND BALL FOR THE HEAD.

3. ROLL TWO LONG CYLINDER SHAPES FOR THE ARMS.

4. ROLL TWO MORE LONG SHAPES FOR THE LEGS.

5. ROLL A CONE SHAPE FOR THE HAT.

24.

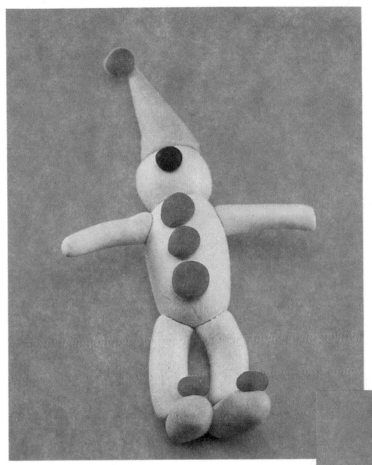

6. ROLL TWO OVALS FOR THE FEET.

7. YOU WILL ALSO NEED SEVEN SMALL ROUND BALLS FOR THE NOSE, THE BUTTONS, AND THE POM-POMS ON THE SHOES AND THE TOP OF THE HAT.

8. LIGHTLY SCORE (ROUGH) THE PIECES THAT GO TOGETHER. ATTACH BY GENTLY PUSHING THE PIECES TOGETHER.

9. ADD DETAILS SUCH AS THE MOUTH, THE EYES AND THE SPOTS.

10. IF YOU USED A CLAY THAT NEEDS TO BE BAKED, REVIEW THE MATERIALS PAGE FOR BAKING INFORMATION.

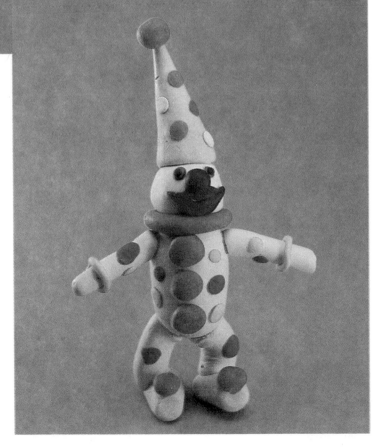

PIG

THIS PROJECT WAS MADE WITH BAKER'S DOUGH CLAY. IT CAN ALSO BE MADE WITH NON-TOXIC PLASTALINA, MODELING COMPOUND, OVEN-HARDENING OR CERAMIC CLAY. SEE MATERIALS PAGE FOR BUYING AND WORKING WITH THE TYPE OF CLAY YOU CHOOSE.

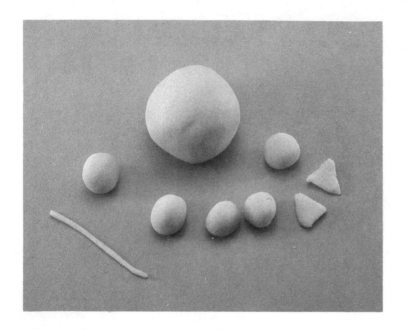

USING YOUR HANDS OR A SMOOTH, CLEAN SURFACE:

1. ROLL A ROUND BALL ABOUT THE SIZE OF A SMALL APRICOT.

2. ROLL FOUR SMALL BALLS FOR THE FEET.

3. ROLL ONE SMALL BALL FOR THE NOSE.

4. FLATTEN A SMALL PIECE OF CLAY AND CUT OUT TWO EARS.

5. ROLL A LONG, THIN TAIL.

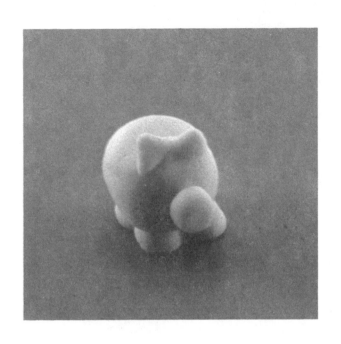

6. PUT THE PIECES TOGETHER BY SCRATCHING AND DAMPENING THE AREAS THAT TOUCH. THEN, GENTLY PUSH THE PIECES TOGETHER.

7. ADD DETAILS SUCH AS THE EYES, THE NOSE AND THE MOUTH. THEN, CURL THE TAIL.

8. IF YOU USED A CLAY THAT NEEDS TO BE BAKED, REVIEW THE MATERIALS PAGE FOR BAKING INFORMATION.

9. AFTER BAKING, YOU CAN PAINT YOUR CLAY IF NECESSARY.

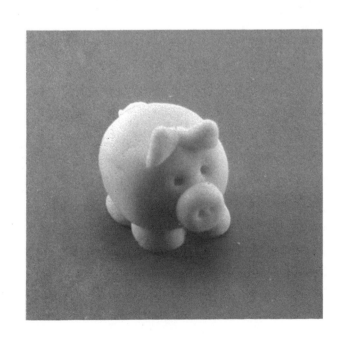

TEDDY BEAR

THIS PROJECT WAS MADE WITH OVEN-HARDENING CLAY. IT CAN ALSO BE MADE WITH BAKER'S DOUGH, NON-TOXIC PLASTALINA, MODELING COMPOUND OR CERAMIC CLAY. SEE MATERIALS PAGE FOR BUYING AND WORKING WITH THE TYPE OF CLAY YOU CHOOSE.

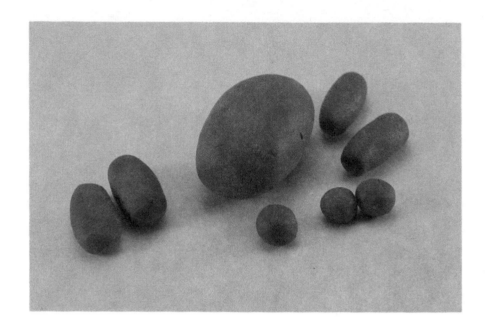

USING YOUR HANDS OR A SMOOTH, CLEAN SURFACE:

1. ROLL AN OVAL SHAPE FOR THE TEDDY BEAR'S BODY AND HEAD.

2. ROLL FOUR OVAL SHAPES FOR THE ARMS AND THE LEGS.

3. ROLL THREE SMALL BALLS, TWO FOR THE EARS, ONE FOR THE MOUTH.

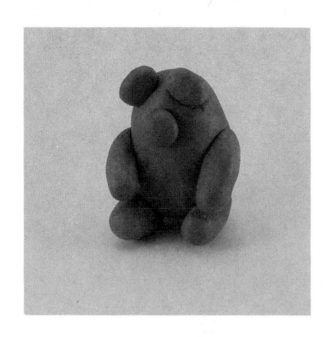

4. SLIGHTLY SCORE (ROUGH) THE PIECES THAT GO TOGETHER. ATTACH THE PIECES, PUSHING GENTLY TO MAKE THEM STAY.

5. ADD DETAILS SUCH AS THE NOSE, THE EYES AND THE EARS.

6. IF YOU USED A CLAY THAT NEEDS TO BE BAKED, REVIEW THE MATERIALS PAGE FOR BAKING INFORMATION.

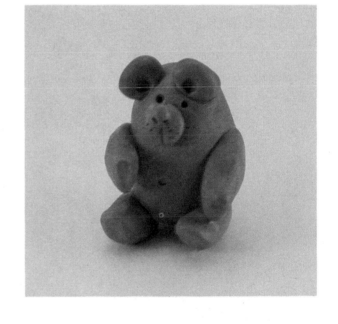

7. AFTER BAKING, YOU CAN PAINT THE TEDDY BEAR IF NECESSARY.

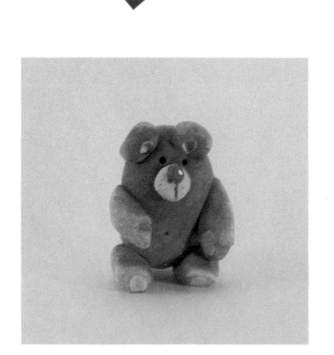

A MAGIC DRAGON

THIS PROJECT WAS MADE WITH CERAMIC CLAY. IT CAN ALSO BE MADE WITH BAKER'S DOUGH, NON-TOXIC PLASTALINA, MODELING COMPOUND OR OVEN- HARDENING CLAY. SEE MATERIALS PAGE FOR BUYING AND WORKING WITH THE TYPE OF CLAY YOU CHOOSE.

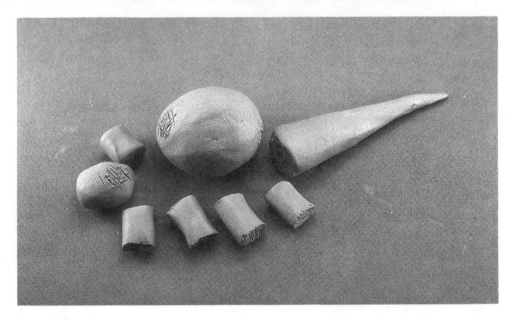

USING YOUR HANDS OR A CLEAN, SMOOTH SURFACE:

1. MAKE A ROUND BALL FOR THE BODY.

2. ROLL AN OVAL SHAPE FOR THE HEAD.

3. ROLL A CYLINDER SHAPE FOR THE NECK.

4. ROLL A LONG, CONE SHAPE FOR THE TAIL.

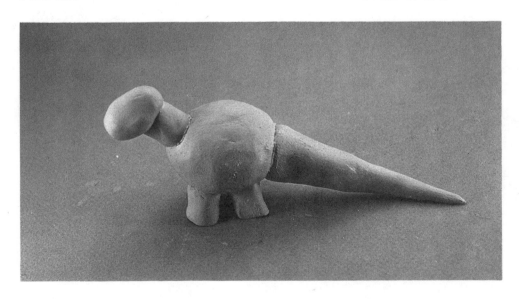

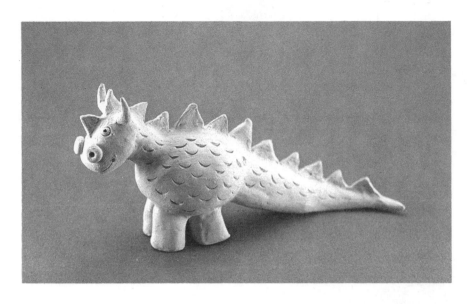

5. ROLL FOUR CYLINDER SHAPES FOR THE LEGS.

6. FLATTEN SOME CLAY AND CUT OUT LOTS OF SMALL TRIANGLES FOR THE BACK SCALES.

7. ATTACH THE PIECES TOGETHER BY "SCORING" (ROUGHING) THE AREAS THAT WILL BE TOUCHING, THEN DAMPEN THE SCORED SURFACES AND GENTLY PUSH THE PIECES TOGETHER.

8. BLEND THE AREAS THAT WERE ATTACHED TO MAKE THEM LOOK LIKE ONE PIECE.

9. ADD DETAILS SUCH AS THE EYES, THE MOUTH AND THE SCALES.

10. TO KEEP YOUR DRAGON FROM CRACKING, HOLLOW OUT AREAS THAT ARE MORE THAN ONE INCH THICK.

11. IF YOU USED A CLAY THAT NEEDS TO BE BAKED, REVIEW THE MATERIALS PAGE FOR BAKING INFORMATION.

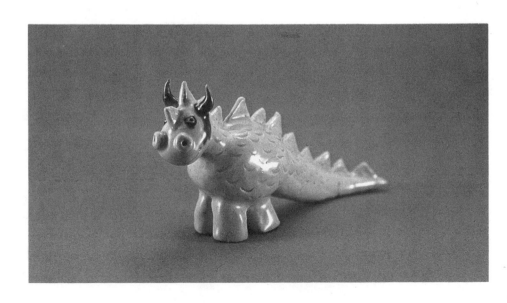

31.

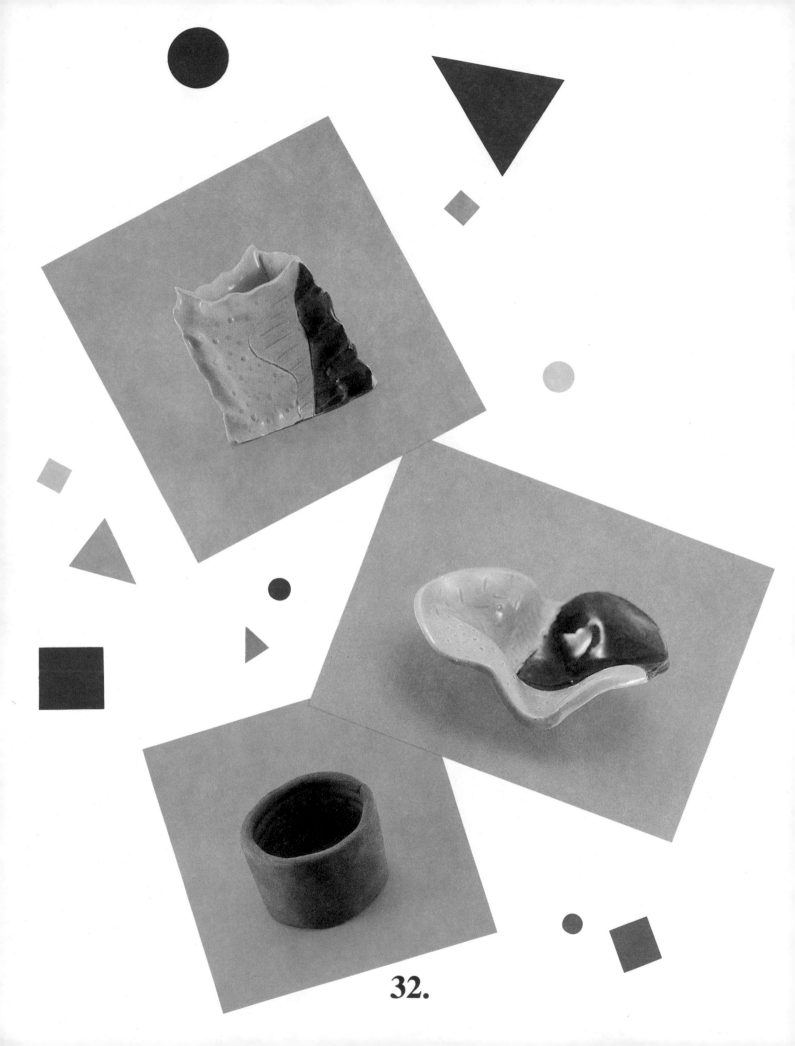

32.

3.

BOWLS AND VASES

Bowls, vases and other similar objects can be fun to create. They also make useful and decorative gifts.

Ceramic clay is best for making bowls and vases because it can be fired in a kiln (a special, very hot oven). This is a process that makes the clay hard enough to hold water without leaking, especially when the clay is painted with glaze and fired again.

In this chapter, you will learn several different methods of making bowls and vases. Using these techniques and your imagination, you should be able to create many wonderful, fun designs.

For information on where to buy ceramic clay, how to glaze and how to fire your clay, look on the materials page.

ROCK-MOLDED POT

THIS PROJECT WAS MADE WITH CERAMIC CLAY. IT CAN ALSO BE MADE WITH MODELING COMPOUND OR OVEN-HARDENING CLAY. SEE MATERIALS PAGE FOR BUYING AND WORKING WITH THE TYPE OF CLAY YOU CHOOSE.

1. FIND A NICELY-SHAPED, SMOOTH ROCK.

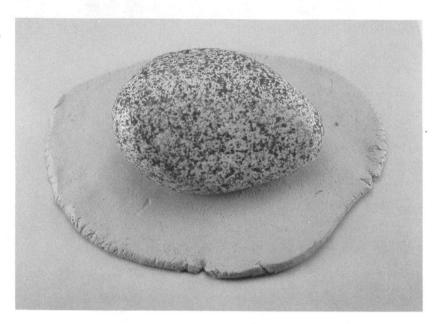

2. ROLL OUT YOUR CLAY UNTIL IT IS BETWEEN ONE-QUARTER AND ONE-HALF INCH THICK.

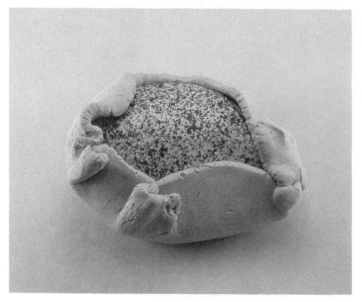

3. WRAP THE CLAY SLAB AROUND THE ROCK.

34.

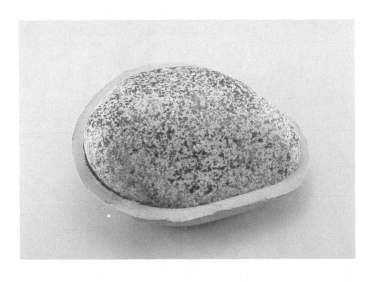

4. CUT THE CLAY WHERE THE ROCK IS WIDEST WITH A TABLE KNIFE.

5. FLATTEN THE BOTTOM OF THE CLAY POT SO IT WILL SIT EVENLY ON THE TABLE.

6. LOOSEN AND REMOVE THE CLAY FROM THE ROCK WHEN THE CLAY IS FIRM ENOUGH TO HOLD ITS SHAPE, BUT NOT COMPLETELY DRY. THIS IS CALLED "LEATHER-HARD."

7. NOW THE CLAY IS READY FOR BAKING OR FIRING. REVIEW THE MATERIALS PAGE FOR BAKING INFORMATION.

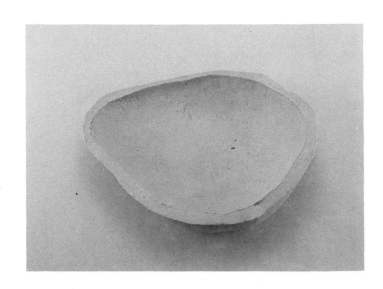

CLAY SLUMPED DISH

THIS PROJECT WAS MADE WITH CERAMIC CLAY. IT CAN ALSO BE MADE WITH MODELING COMPOUND OR OVEN-HARDENING CLAY. SEE MATERIALS PAGE FOR BUYING AND WORKING WITH THE TYPE OF CLAY YOU CHOOSE.

1. ON A SMOOTH, CLEAN SURFACE, ROLL OUT YOUR CLAY UNTIL IT IS BETWEEN ONE-QUARTER AND ONE-HALF INCH THICK.

2. CUT OUT YOUR SHAPE WITH A TABLE KNIFE OR CLAY TOOL. MAKE THE SHAPE SHOWN HERE OR CREATE YOUR OWN.

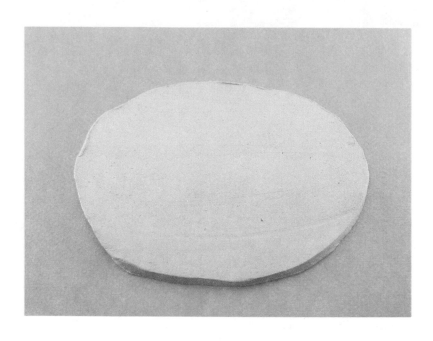

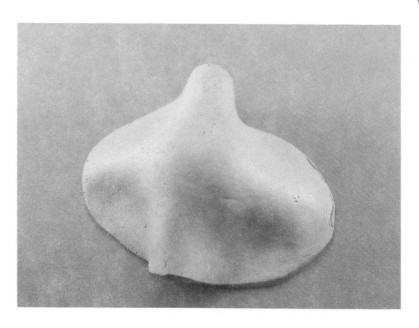

3. FIND SOME SMALL, HARD, SMOOTH OBJECTS (ASK PERMISSION IF THEY DON'T BELONG TO YOU). PUT THE CLAY OVER THE TOP OF THE OBJECTS. LET CLAY "SLUMP" (SEE GLOSSARY) INTO AN ARTISTIC SHAPE.

36.

4. ADD TEXTURE TO THE
SURFACE IF YOU WISH.

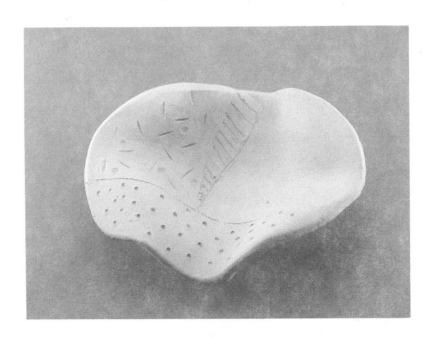

5. NOW YOUR CLAY IS READY FOR
BAKING OR FIRING AND GLAZING.
REVIEW MATERIALS PAGE FOR
BAKING INFORMATION.

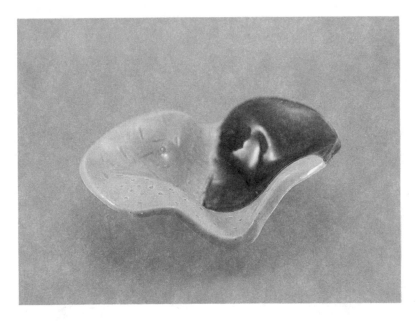

PINCH POT

THIS PROJECT WAS MADE WITH CERAMIC CLAY. IT CAN ALSO BE MADE WITH MODELING COMPOUND OR OVEN-HARDENING CLAY. SEE MATERIALS PAGE FOR BUYING AND WORKING WITH THE TYPE OF CLAY YOU CHOOSE.

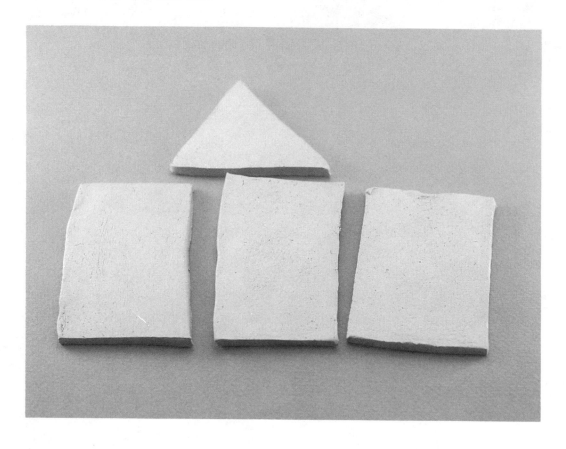

1. ON A SMOOTH, CLEAN SURFACE, ROLL OUT YOUR CLAY UNTIL IT IS ABOUT ONE-HALF INCH THICK.

2. CUT OUT YOUR CLAY SHAPES WITH A CLAY TOOL OR TABLE KNIFE. MAKE THE SHAPES SHOWN OR CREATE YOUR OWN.

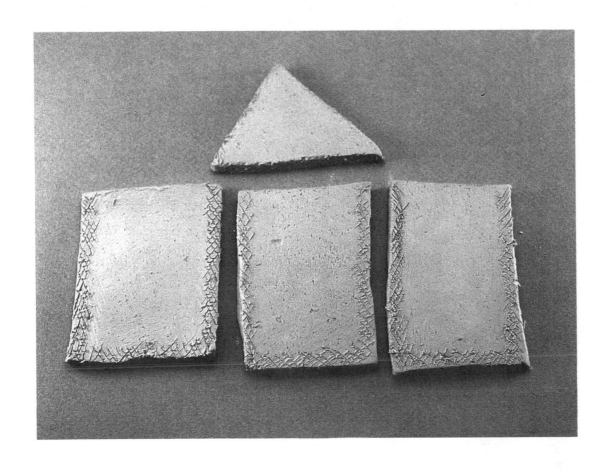

3. SCORE (ROUGH) THE CLAY
WHERE THE PIECES ATTACH TO
EACH OTHER.

4. DAMPEN THE SCORED SURFACE
OF YOUR CLAY. ATTACH BY
GENTLY PINCHING THE CLAY
TOGETHER.

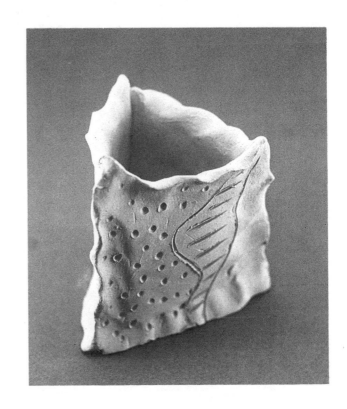

39.

PINCH POT

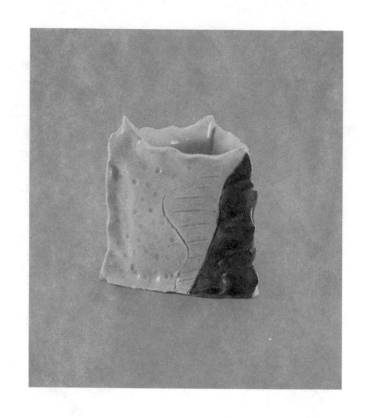

5. KEEP PINCHING UNTIL YOU CREATE THE SHAPE THAT YOU WANT.

6. NOW YOUR CLAY IS READY FOR BAKING OR FIRING AND GLAZING. REVIEW MATERIALS PAGE FOR BAKING INFORMATION.

COIL VASE

THIS PROJECT WAS MADE WITH OVEN-HARDENING CLAY. IT CAN ALSO BE MADE WITH CERAMIC CLAY. SEE MATERIALS PAGE FOR BUYING AND WORKING WITH THE TYPE OF CLAY YOU CHOOSE.

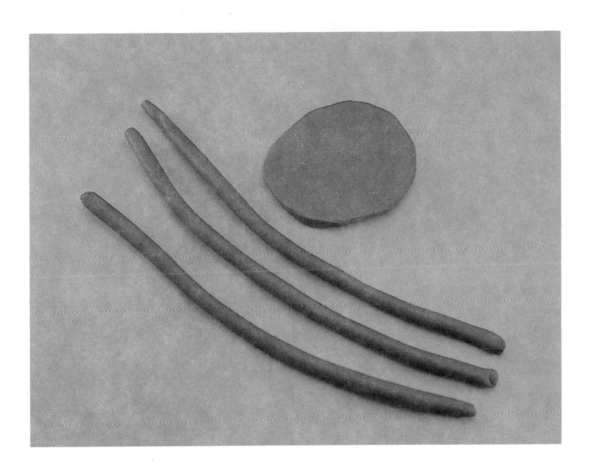

1. ROLL OUT COILS ON A SMOOTH, CLEAN SURFACE. THEY SHOULD BE BETWEEN ONE-HALF AND THREE-QUARTERS INCH THICK.

2. MAKE THE BASE BY ROLLING A ROUND BALL, THEN FLATTEN IT TO ONE-HALF INCH THICK.

COIL VASE

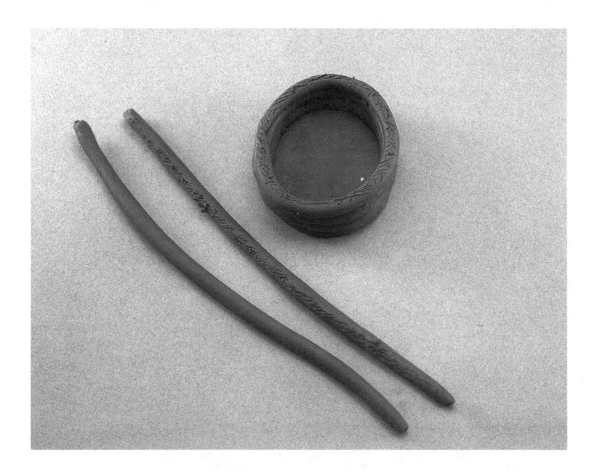

3. START ADDING COILS. REMEMBER TO SCORE EACH SURFACE THAT WILL TOUCH OR THE COILS WON'T STAY ATTACHED. SCORE THE SURFACES BY SCRATCHING WITH A CLAY TOOL OR A KITCHEN KNIFE. THEN, DAMPEN AND WEDGE THE COILS TOGETHER WITH A TOOL OR YOUR FINGERS.

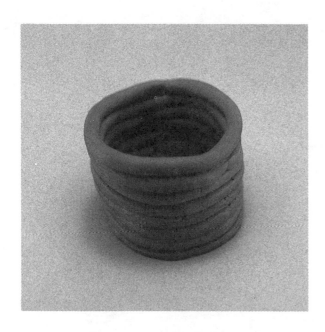

4. KEEP ADDING COILS UNTIL THE VASE IS THE SIZE AND SHAPE YOU WANT. BE SURE TO KEEP THE VASE DAMP UNTIL IT IS COMPLETE.

5. YOU CAN SMOOTH OUT THE SIDES WITH YOUR TOOLS OR YOUR HANDS. ALWAYS REMEMBER TO BE CAREFUL WHEN USING TOOLS.

6. NOW YOUR CLAY IS READY FOR BAKING OR FIRING AND GLAZING. REVIEW MATERIALS PAGE FOR BAKING INFORMATION.

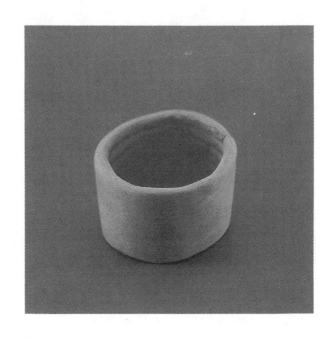

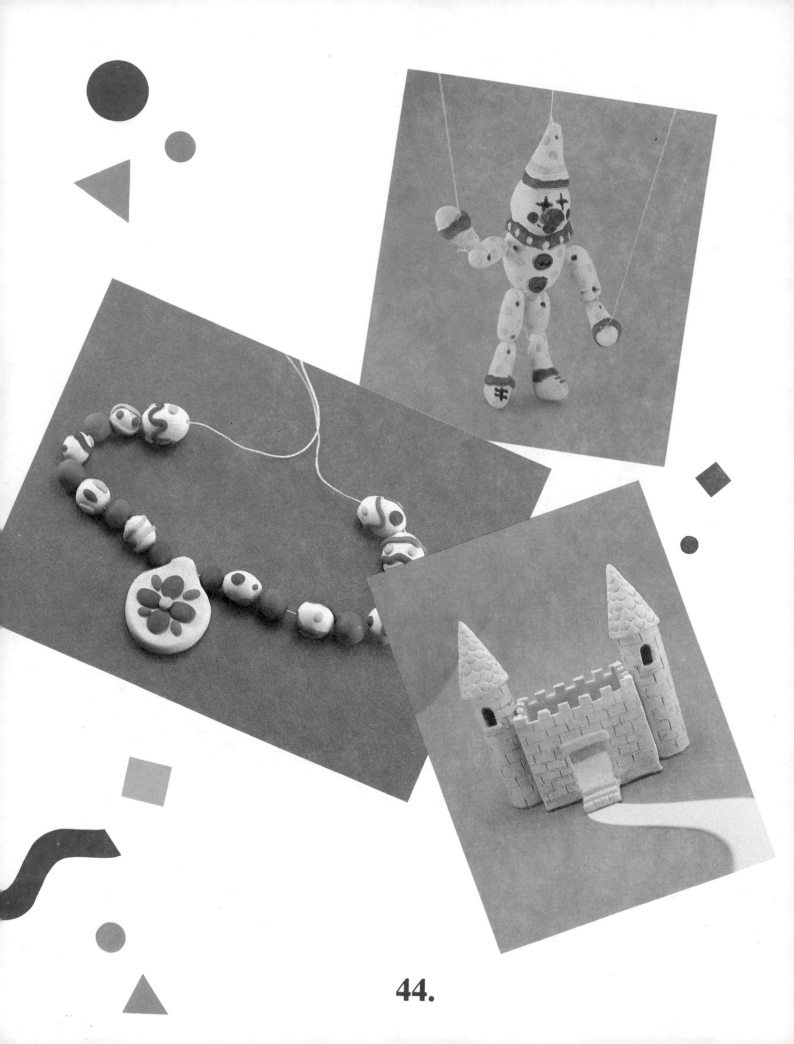

4.

PLACES AND FUN THINGS

Castles, jewelry, dolls, trains—everything we see is made up of many different shapes. If we really look at an object, we can picture the shapes necessary to re-create it with clay. In fact, using the methods we've learned so far, we can make just about anything we can imagine.

Now it's time to have some more fun by trying things that may be a little harder. This is where you really get to use your imagination!

PUPPET

THIS PROJECT WAS MADE WITH BAKER'S DOUGH CLAY. IT CAN ALSO BE MADE WITH MODELING COMPOUND, OVEN-HARDENING OR CERAMIC CLAY. SEE MATERIALS PAGE FOR BUYING AND WORKING WITH THE TYPE OF CLAY YOU CHOOSE.

1. USING YOUR HANDS OR A CLEAN, SMOOTH SURFACE, MAKE AN OVAL SHAPE FOR THE BODY.

2. ROLL A ROUND BALL FOR THE HEAD.

3. ROLL A CONE FOR THE HAT.

4. ATTACH THE HEAD, THE HAT AND THE BODY BY ROUGHING THE SURFACES THAT WILL TOUCH, THEN GENTLY PUSHING THE PIECES TOGETHER.

5. ADD DETAILS SUCH AS THE EYES, THE MOUTH, THE NOSE, THE HAIR, THE BUTTONS AND THE RUFFLE AROUND THE NECK.

6. ROLL EIGHT CYLINDER SHAPES FOR THE ARMS AND THE LEGS.

7. ADD FEET TO TWO OF THE CYLINDERS AND HANDS TO TWO OF THE OTHER CYLINDERS.

8. ADD DETAILS TO THE FEET AND HANDS.

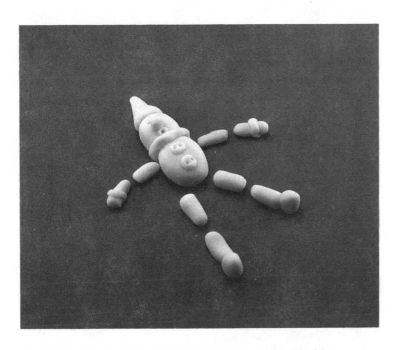

9. USING A TOOTHPICK OR A CLAY TOOL, PUSH HOLES INTO THE ENDS OF THE CYLINDER SHAPES, INTO THE SHOULDER AND HIPS OF THE BODY SHAPE, AND IN THE HANDS AND THE END OF THE HAT. MAKE THE HOLES BIG ENOUGH SO THEY WON'T CLOSE WHILE BAKING.

10. NOW YOU ARE READY TO BAKE THE PUPPET. REVIEW MATERIALS PAGE FOR BAKING INFORMATION ON THE TYPE OF CLAY YOU USED.

11. AFTER BAKING, YOU CAN PAINT YOUR PUPPET IF NECESSARY.

12. STRING YOUR PUPPET THE WAY THE EXAMPLES SHOW. NOW YOU ARE READY FOR A PUPPET SHOW!

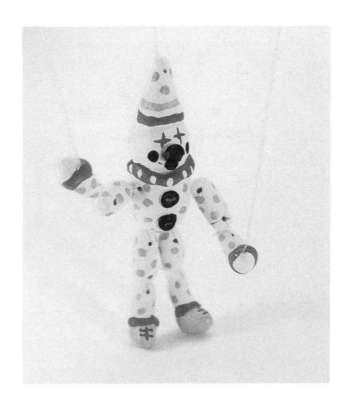

COLORFUL BEADS

THIS PROJECT WAS MADE WITH MODELING COMPOUND CLAY. IT CAN ALSO BE MADE WITH BAKER'S DOUGH, OVEN-HARDENING OR CERAMIC CLAY. SEE MATERIALS PAGE FOR BUYING AND WORKING WITH THE TYPE OF CLAY YOU CHOOSE.

1. USING YOUR HANDS OR A CLEAN, SMOOTH SURFACE, ROLL DIFFERENT SIZES AND SHAPES OF BEADS.

2. POKE A HOLE THROUGH THE MIDDLE OF EACH BEAD WITH A SHARP OBJECT, A CLAY TOOL OR A TOOTHPICK.

3. ADD DIFFERENT TEXTURES OR DETAILS TO YOUR BEADS USING CLAY TOOLS, A PENCIL OR A TABLE KNIFE. TRY ADDING PIECES OF DIFFERENT COLORED CLAY.

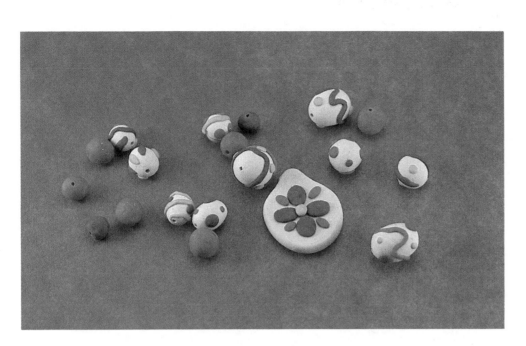

4. NOW IT IS TIME TO BAKE THE BEADS. REVIEW MATERIALS PAGE FOR BAKING INFORMATION ON THE TYPE OF CLAY YOU USED.

5. NOW STRING YOUR BEADS, USING SOME STRING, THE BEADS AND A LITTLE IMAGINATION.

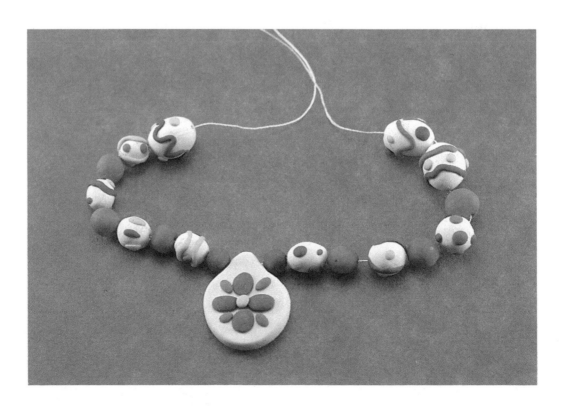

A CASTLE

THIS PROJECT WAS MADE WITH CERAMIC CLAY. IT CAN ALSO BE MADE WITH BAKER'S DOUGH, NON-TOXIC PLASTALINA, MODELING COMPOUND OR OVEN- HARDENING CLAY. SEE MATERIALS PAGE FOR BUYING AND WORKING WITH THE TYPE OF CLAY YOU CHOOSE.

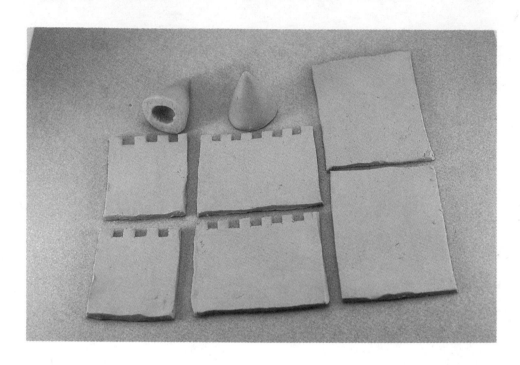

1. ROLL OUT THE CLAY ON A CLEAN, DRY SURFACE UNTIL IT'S ABOUT ONE-HALF INCH THICK.

2. CUT OUT THE SHAPES—THE TOWERS, THE ROOFS, THE WALLS, AND THE DOOR—WITH A TABLE KNIFE OR CLAY TOOL. USE THE SHAPES SHOWN IN THE EXAMPLE OR CREATE YOUR OWN. IF YOU MAKE YOUR TOWERS LIKE THE EXAMPLE, BE SURE TO HOLLOW OUT THE INSIDE OF THE CONE SHAPES. (CERAMIC CLAY EXPANDS, LIKE A CAKE, WHEN IT IS BAKING. THIS CAN CAUSE THE CLAY TO CRACK.)

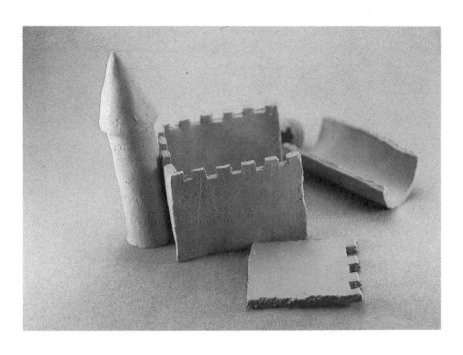

3. SCORE (ROUGH) THE PIECES THAT ARE TO BE ATTACHED TO EACH OTHER. DAMPEN SCORED SURFACES AND GENTLY PUSH THEM TOGETHER. USING YOUR HANDS OR CLAY TOOLS, SMOOTH OUT THE ROUGH EDGES. (ALWAYS KEEP YOUR PROJECT DAMP WHILE WORKING ON IT.)

4. USE A TOOTHPICK OR CLAY TOOLS TO ADD DETAILS SUCH AS THE WINDOWS, AND THE STONES.

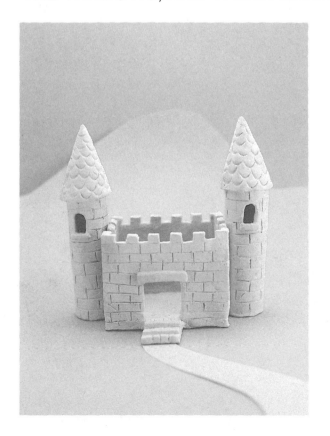

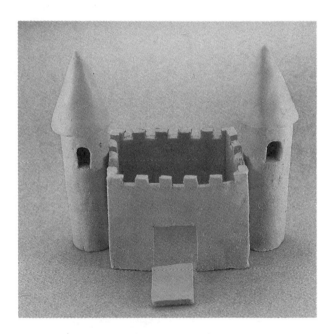

5. IF YOU USED A CLAY THAT NEEDS TO BE BAKED, REVIEW THE MATERIALS PAGE FOR BAKING INFORMATION.

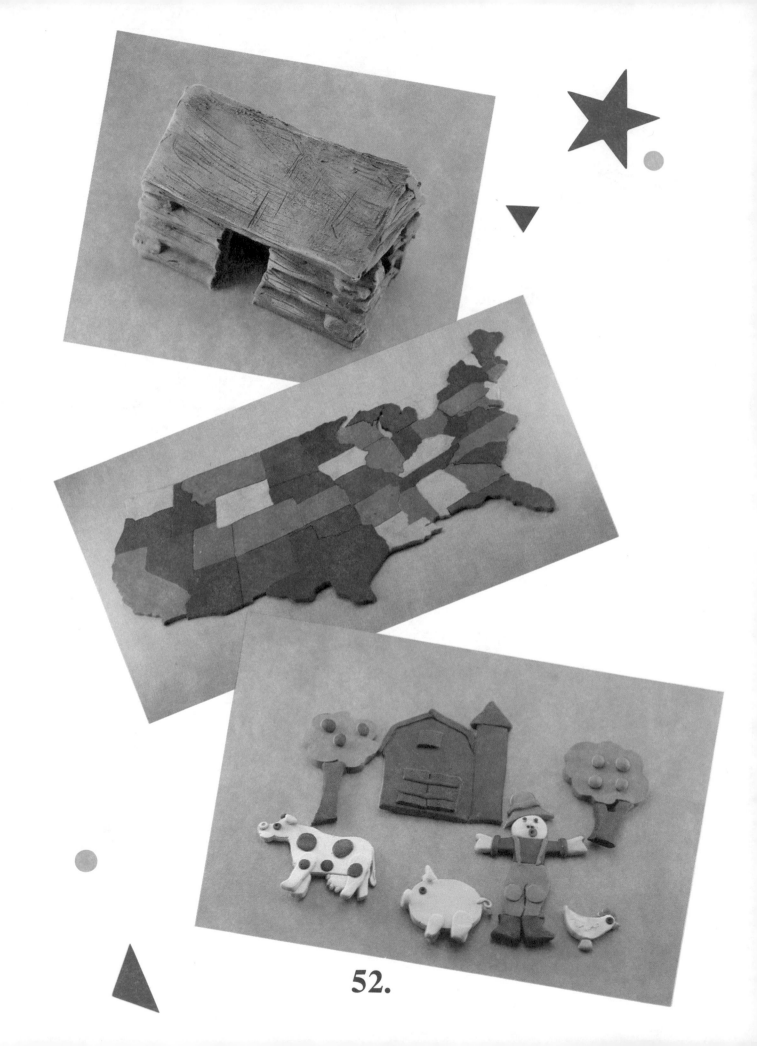

52.

PROJECTS

You can enjoy making these projects at home or at school. Now that you've learned about the many different types of clay and how to work with each of them, you might want to use them on other projects that are more difficult or complicated.

Perhaps you have a school project in mind, or want to earn some extra credit (ask your teacher about this). Maybe you want to make a gift for your parents or a friend,or you might just want to do it for fun. Whatever your reason, remember to use the clay best suited for your project, plan out how you will create it, and use your imagination.

FARM

THIS PROJECT WAS MADE WITH MODELING COMPOUND CLAY. IT CAN ALSO BE MADE WITH BAKER'S DOUGH, OVEN-HARDENING OR CERAMIC CLAY. SEE MATERIALS PAGE FOR BUYING AND WORKING WITH THE TYPE OF CLAY YOU CHOOSE.

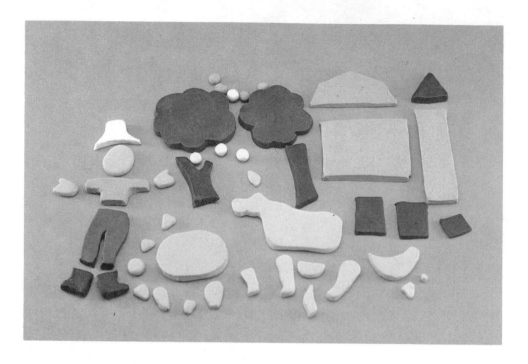

1. ROLL OUT THE CLAY ON A CLEAN, DRY SURFACE UNTIL IT IS BETWEEN ONE-QUARTER AND ONE-HALF INCH THICK.

2. CUT OUT THE SHAPES—THE ORANGE TREES, THE BARN, THE PIG, THE COW, THE CHICKEN, AND THE FARMER—WITH CLAY TOOLS OR A TABLE KNIFE (BE CAREFUL). MAKE THE SHAPES AS SHOWN IN OUR EXAMPLE OR CREATE YOUR OWN.

3. USING YOUR HANDS, MOLD THE SHAPES AND ATTACH THE PIECES TOGETHER.

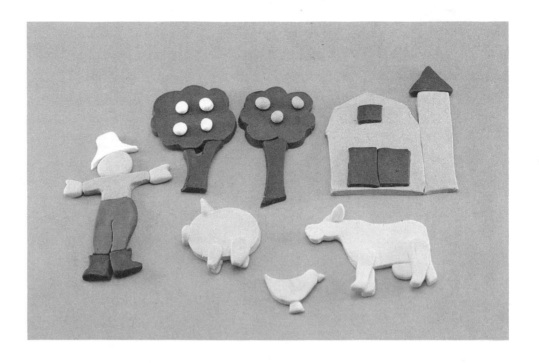

4. ADD DETAILS SUCH AS THEIR EYES, THEIR MOUTHS AND THEIR EARS; USING MORE CLAY OR A TOOTHPICK.

5. IF YOU USED A CLAY THAT NEEDS TO BE BAKED, REVIEW THE MATERIALS PAGE FOR BAKING INFORMATION. FOR THIS PROJECT, WE GLUED THE CLAY FIGURES TO CONSTRUCTION PAPER.

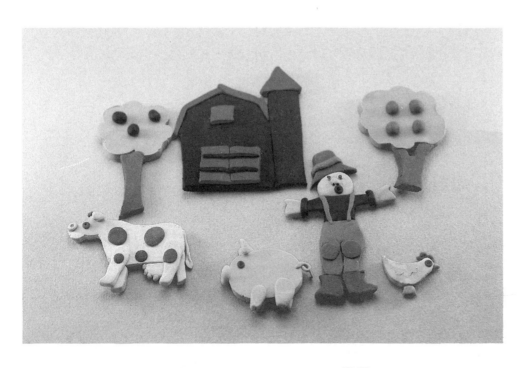

A SMALL TOWN

THIS PROJECT WAS MADE WITH OVEN-HARDENING CLAY. IT CAN ALSO BE MADE WITH NON-TOXIC PLASTALINA, MODELING COMPOUND OR CERAMIC CLAY. SEE MATERIALS PAGE FOR BUYING AND WORKING WITH THE TYPE OF CLAY YOU CHOOSE.

1. ROLL OUT THE CLAY ON A CLEAN, DRY SURFACE. MAKE DIFFERENT SIZED SQUARES AND RECTANGLES USING A CLAY TOOL OR TABLE KNIFE. THEN, MOLD THE CLAY WITH YOUR HANDS.

2. MAKE A ROOF FOR YOUR HOUSE BY CUTTING OUT A TRIANGLE THAT WILL FIT. ATTACH THE ROOF TO THE HOUSE BY ROUGHING THE SURFACES THAT WILL TOUCH, THEN GENTLY PUSHING THE PIECES TOGETHER.

3. ROLL OUT A FLAT PIECE OF CLAY AND CUT OUT WINDOWS, DOORS, PORCHES, SIGNS AND TRIM FOR YOUR BUILDINGS. ADD THESE DETAILS TO YOUR BUILDINGS BY ROUGHING THE SURFACES THAT WILL TOUCH, THEN GENTLY PUSH THEM TOGETHER.

4. MAKE TREES BY ROLLING CYLINDERS FOR THE TREE TRUNKS AND ROUND BALLS FOR THE TREETOPS, THEN ATTACH THE PIECES.

5. MAKE A CAR BY MOLDING A SHAPE FOR THE BODY OF THE CAR. THEN, ROLL A CYLINDER AND SLICE OFF FOUR WHEELS. ATTACH THESE WHEELS TO THE CAR.

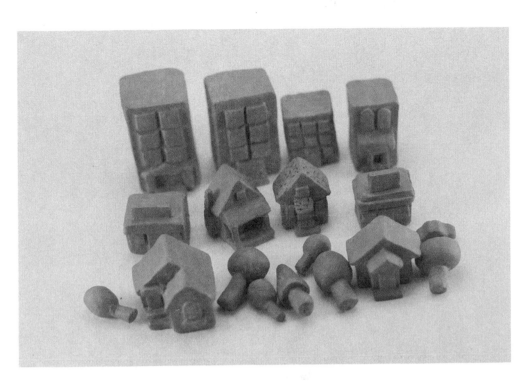

6. IF YOU USED A CLAY THAT NEEDS TO BE BAKED, REVIEW THE MATERIALS PAGE FOR BAKING INFORMATION.

7. WE USED ACRYLIC PAINT TO TURN THE PLAIN CLAY SHAPES AND BOARD INTO A COLORFUL CITY.

8. WE MADE THE STREETS AND THE GRASS OUT OF CONSTRUCTION PAPER.

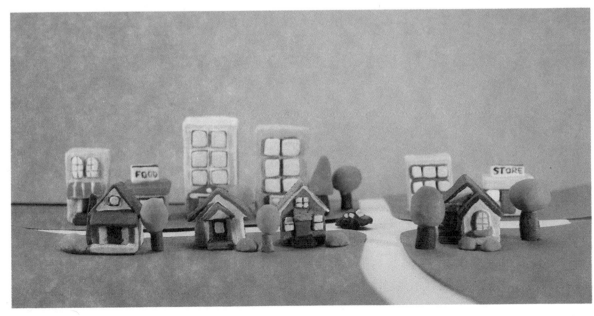

A LOG CABIN

THIS PROJECT WAS MADE WITH OVEN-HARDENING CLAY. WE RECOMMEND USING OVEN-HARDENING OR CERAMIC CLAY, BUT YOU CAN ALSO USE NON-TOXIC PLASTALINA OR MODELING COMPOUND CLAY IF YOU WISH. SEE MATERIALS PAGE FOR BUYING AND WORKING WITH THE TYPE OF CLAY YOU CHOOSE.

1. ROLL CLAY OUT ON A CLEAN, SMOOTH SURFACE, MAKING A LONG CYLINDER ABOUT ONE-HALF INCH THICK. THIS WILL BE CUT TO MAKE THE LOGS FOR YOUR CABIN.

2. CUT THE LOGS TO THE LENGTHS YOU NEED. HALF OF THE LOGS SHOULD BE ABOUT EIGHT INCHES LONG, THE OTHER HALF SHOULD BE ABOUT FOUR INCHES LONG. ROLL OUT MORE CYLINDERS IF NECESSARY.

3. SLIGHTLY PINCH THE ENDS OF THE LOGS SO THAT THEY STACK WELL. SCORE THE SURFACES THAT WILL TOUCH, THEN GENTLY STACK THE LOGS.

4. WHEN YOU FINISH THE WALLS, CUT OUT A DOOR AND WINDOWS.

5. TO MAKE THE ROOF, ROLL OUT A FLAT PIECE OF CLAY ABOUT ONE-HALF INCH THICK (OR SLIGHTLY LESS). CUT OUT BOTH SIDES OF THE ROOF.

6. TEXTURE THE ROOF AND THE LOGS TO MAKE THEM LOOK MORE REALISTIC.

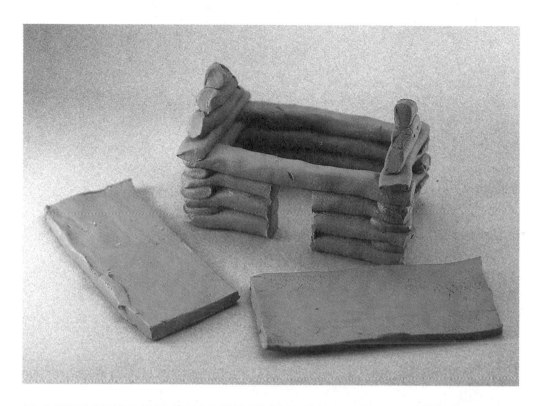

7. LET YOUR PROJECT DRY UNTIL IT IS "LEATHER HARD" (FIRM, BUT STILL PLIABLE). SCRATCH OR SCORE LITTLE CUTS ON TOP OF THE LOGS AND ON THE INSIDE OF THE ROOF WHERE THEY WILL MEET. NEXT, USING A "SLIP MIXTURE" (A THIN PASTE OF CLAY AND WATER THAT WILL ACT AS A KIND OF GLUE), PAINT THE SCORED AREA OF THE LOGS AND CAREFULLY PLACE THE ROOF ON TOP OF YOUR WALLS, MATCHING THE AREAS YOU SCORED.

8. IF YOU USED A CLAY THAT NEEDS TO BE BAKED, REVIEW THE MATERIALS PAGE FOR BAKING INFORMATION.

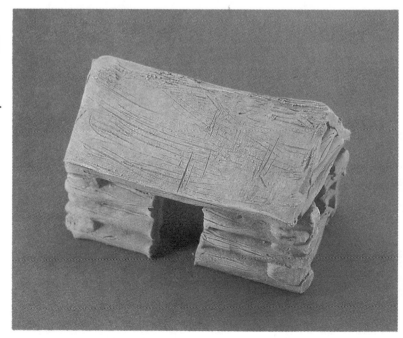

SOLAR SYSTEM

THIS PROJECT WAS MADE WITH MODELING COMPOUND CLAY. IT CAN ALSO BE MADE WITH OVEN-HARDENING OR CERAMIC CLAY. SEE MATERIALS PAGE FOR BUYING AND WORKING WITH THE TYPE OF CLAY YOU CHOOSE.

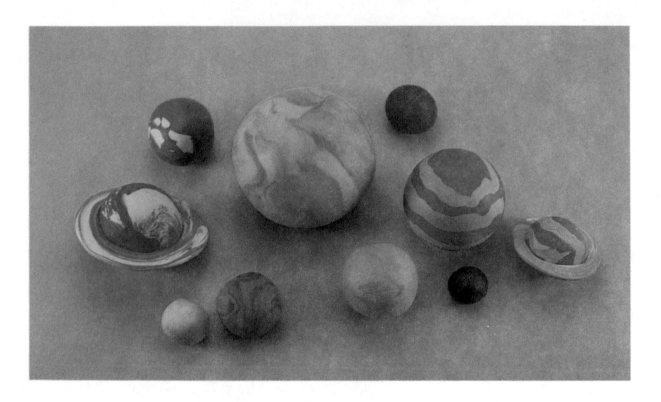

YOU WILL NEED A PICTURE OF THE SOLAR SYSTEM AND SOME STIFF WIRE THAT WILL HOLD THE WEIGHT OF THE PLANETS. (ASK PERMISSION IF THE WIRE DOES NOT BELONG TO YOU.)

1. ROLL A BALL FOR EACH PLANET, USE THE COLOR YOU THINK IS BEST SUITED FOR EACH PLANET.

2. ADD DETAILS TO EACH PLANET (SEE EXAMPLE).

3. ROLL A LARGE BALL FOR THE SUN.

4. MAKE THE BASE. FOLLOW THE EXAMPLE OR USE YOUR IMAGINATION.

5. PUSH A PIECE OF WIRE INTO THE BASE. LET IT STICK OUT OF THE BASE ABOUT TWO INCHES. LEAVE THE WIRE IN PLACE WHILE BAKING.

6. ATTACH A PIECE OF WIRE TO EACH PLANET (USE DIFFERENT LENGTHS OF WIRE ACCORDING TO THE DISTANCE OF THE PLANET TO THE SUN.) LEAVE THE WIRES IN PLACE WHILE BAKING.

7. USING A PIECE OF WIRE, POKE HOLES INTO THE SUN WHERE THE WIRE FROM THE PLANETS AND BASE WILL BE ATTACHED.

8. BAKE THE SUN, THE PLANETS AND THE BASE (BE CAREFUL, THE WIRES GET VERY HOT). SEE MATERIALS PAGE FOR BAKING INSTRUCTIONS.

9. AFTER THE WIRES AND CLAY HAVE COOLED, GLUE THE BASE WIRE INTO THE HOLE AT THE BOTTOM OF THE SUN. LET DRY.

10. FINALLY, GLUE THE PLANET WIRES INTO THE HOLES ON THE SIDES OF THE SUN THAT WERE MADE IN STEP 7. LET DRY.

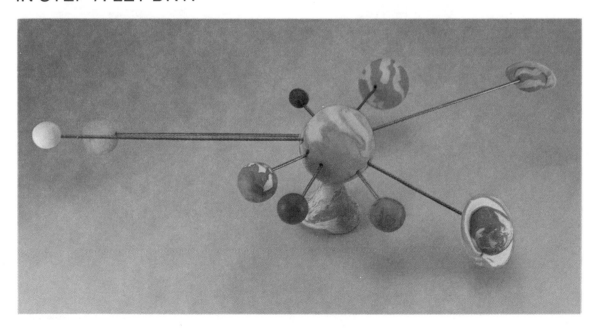

UNITED STATES MAP

THIS PROJECT WAS MADE WITH MODELING COMPOUND CLAY. WE RECOMMEND USING MODELING COMPOUND OR NON-TOXIC PLASTALINA CLAY, BUT YOU CAN ALSO USE BAKER'S DOUGH, OVEN-HARDENING OR CERAMIC CLAY IF YOU WISH. SEE MATERIALS PAGE FOR BUYING AND WORKING WITH THE CLAY YOU CHOOSE.

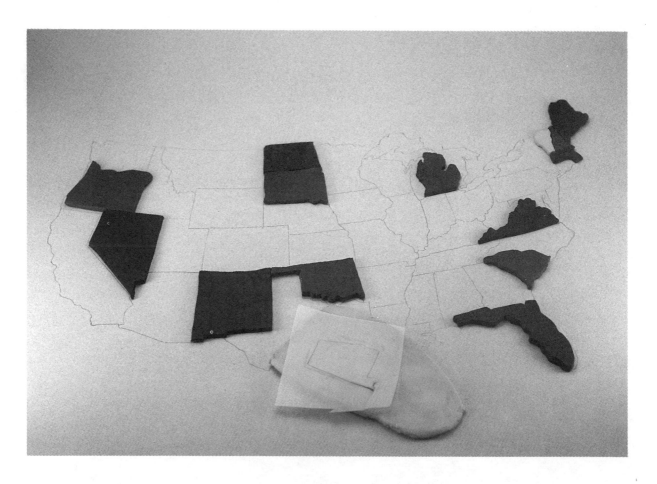

YOU WILL NEED A MAP TO USE AS AN EXAMPLE.

1. DRAW AN OUTLINE OF THE UNITED STATES ON A PAINTED PIECE OF WOOD.

2. USING YOUR MAP, TRACE THE
STATES ON A PIECE OF PAPER.
CUT OUT EACH STATE,
CAREFULLY FOLLOWING THEIR
SHAPES. ONE AT A TIME, LAY THE
PAPER SHAPES ON THE CLAY. CUT
OUT EACH STATE, USING THE
PAPER AS A STENCIL.

3. IF YOU USED A CLAY THAT
NEEDS TO BE BAKED, REVIEW THE
MATERIALS PAGE FOR BAKING
INFORMATION.

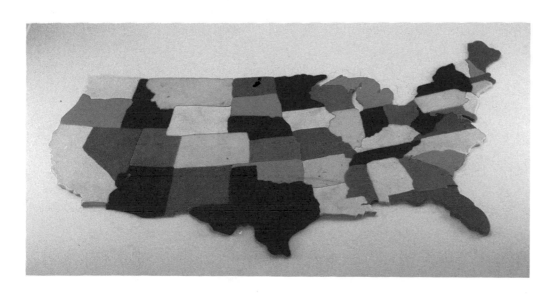